9018

LL 95

D0855647

INGRES

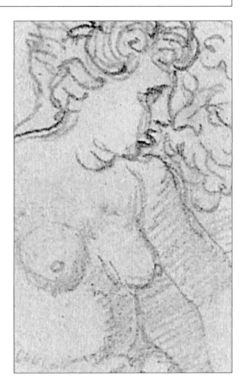

Patrick Bade

Publishing director: Jean-Paul Manzo
Texts by: Patrick Bade
Designed by: Oliver Hickey
Reprographics Dr. Mänken GmbH,
and Technical Bonn
Production:

Printed and bound 1999 in Europe

ISBN 1 85995 471 5

INGRES

"The complete expression of an incomplete intelligence" was Eugene Delacroix's devastating assessment of the art of his rival Jean-Auguste-Dominique Ingres (1780-1867). For nearly half a century French painting polarized around these two contrasting and mutually antagonistic artists.

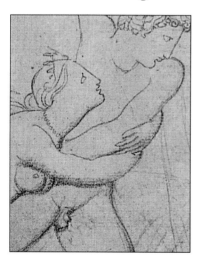

The battle lines were drawn up in the 1820s in a series of what became very public artistic duels between the two men at the Paris Salon. In 1824, Ingres *Vow of Louis XIII*, intended as a statement of artistic orthodoxy and almost abject devotion to Raphael, confronted Delacroix's brutal and disturbingly sexy *Massacre at Scio*. Three years later the two artists took even more extreme positions, with Delacroix exhibiting his orgiastic *Death of Sardanapalus* and Ingres lining up the good and the great men (women are only included in allegorical roles) of Western culture, as though for a celestial school photograph, in his *Apotheosis of Homer*.

3

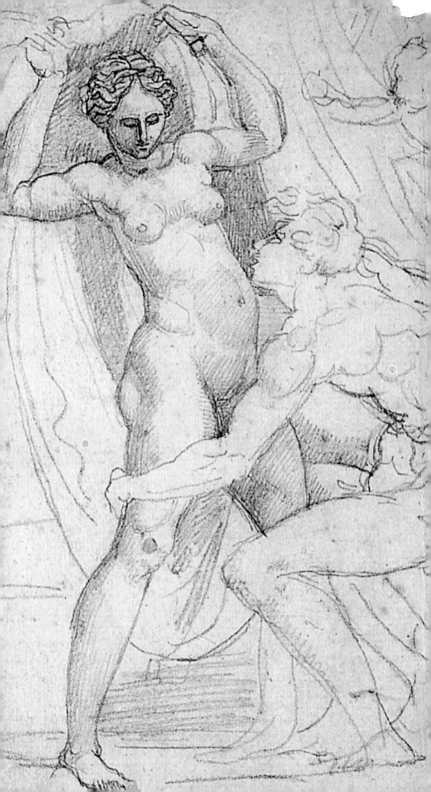

These paintings seemed to embody everything that both the friends and the enemies of the two artists believed they stood for: passion, sensuality, colour and movement in Delacroix and the arch Romantic gravitas and the supremacy of line in Ingres, the die-hard defender of the classical tradition. Hindsight has brought these polarities into question and the divisions between the two artists no longer seem so clear-cut. Delacroix was every bit as engaged with the art of the past as Ingres and could even say of himself, "Je suis un pur classique."

5

1. Mars Embracing Venus

The position of rigid orthodoxy and fusty conservatism that Ingres assumed in middle age masked a nature that was inherently far more passionate than that of Delacroix. It was Ingres, rather than the cerebral and calculating Delacroix, who allowed himself to be ruled by his emotions and his senses. The naive freshness of vision in Ingres' best pictures perfectly exemplifies Baudelaire's Romantic definition of genius as "childhood recaptured at will."

2. Nude Couple

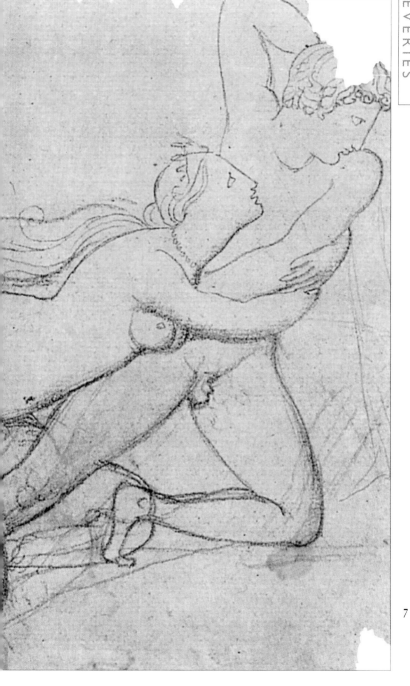

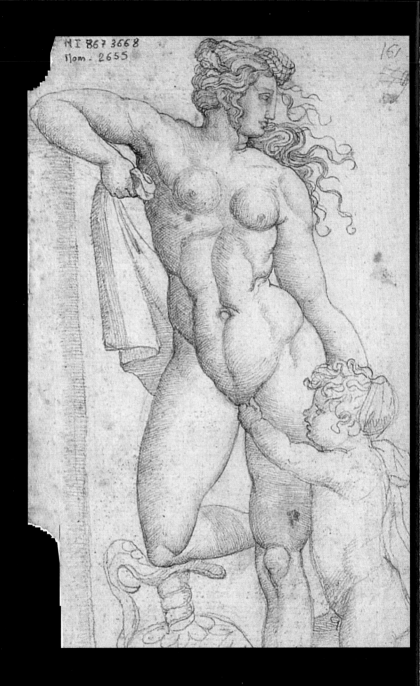

3. Woman Caressed by Cupid

It is in their attitudes towards and depiction of women that the two artists offer the most fascinating comparisons. In their real-life relations with women, they followed very different paths. Delacroix was a cynical libertine, far too egotistical to marry or to form long-lasting relationships. Ingres was twice happily married. Devastated by the death of his first wife in 1849, he soon began to miss his domestic comforts and set about looking for another spouse with more common sense and practicality than romantic passion. A much repeated, possibly apocryphal, but nevertheless believable anecdote has Ingres so excited by the sight of female dancers at the Opera that he would cry out to his wife, "Back to the carriage, Mme Ingres" and make love to her furiously all the way home. Such extremes of

impetuous sensuality within the dutiful confines of conjugal relations are indeed just what one might expect from the author of paintings that combine eroticism with an almost religious reverence for tradition. It is impossible to imagine Ingres recording casual sexual encounters with models in a diary as Delacroix did or complaining that a model had "carried away with her part of the energy" needed for painting.

9

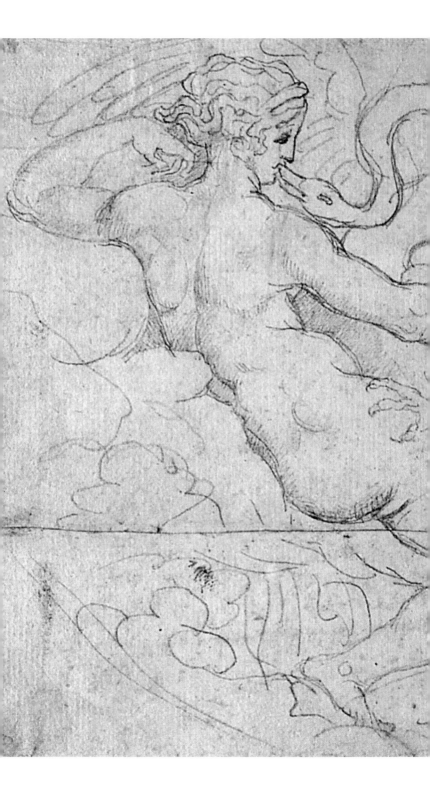

In recent years both Ingres and Delacroix have been roundly condemned by feminists as extreme examples of the tendency of white, male artists to "objectify" the female body. What Ingres did not share with Delacroix though was a taste for violence and cruelty towards women. Delacroix's gloating satisfaction in making love to the girl who was posing for the voluptuous corpse in the foreground of the *Massacre at Scio* (which he recorded in his diary on the 24 January 1824) would have been as alien to Ingres as was the carnage of *Sardanapalus* in which the women fall into attitudes of sexual abandon as they are being slaughtered. Ingres' "objectification" of the female shows itself in the voluptuous passivity of the women he depicted.

11

4. Leda and the Swan

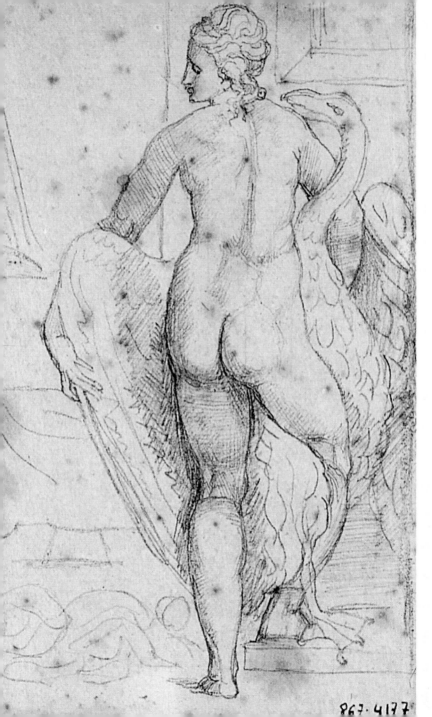

867·4177

Whether banker's wives and titled ladies in well-appointed Second Empire drawing rooms, Greek goddesses or odalisques in harems, this passivity is common to them all. One is tempted to ask if these strangely vegetal women are enigmatic or merely vacuous. With rare exceptions (the charming Baronne de Rothschild and the feisty old Comtesse de Tournon, who by virtue of her age is in any case excluded from Ingres' canon of female beauty), the faces of Ingres' women are not animated by intelligence. Perhaps, like Renoir, an artist with somewhat similar erotic sensibilities, Ingres deliberately engaged in trivial conversation in order to achieve the desired expression of bored vacuity. As in the case of Renoir, Ingres' women seem to belong to one large family. Ingres' first wife, Madeleine Chapelle, could be the older sister of Mlle Riviere. They have similar smooth and wide symmetrical faces with perfectly arched eyebrows and a sweetly submissive gaze that holds no secrets.

13

5. Leda and the Swan

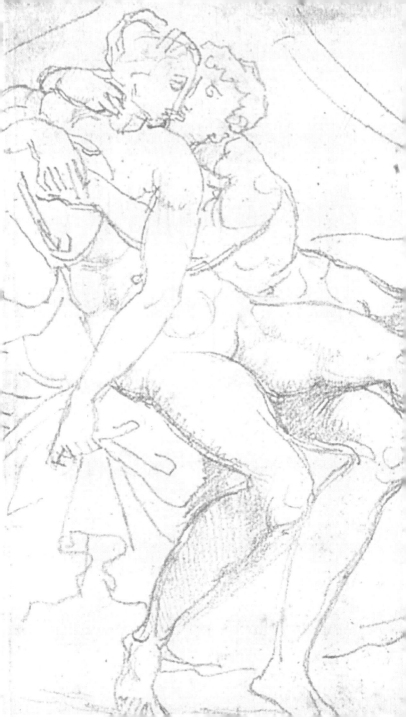

The passivity of Ingres' women is expressed not only through facial expression (or lack of it) and pose, but also through an apparent lack of bone structure beneath the surface of the skin and through strange deformations of anatomy. These deformations, far more pronounced in his female than in his male bodies, were a persistent feature from first to last in his career and have always been one of the most controversial aspects of Ingres' work. In the early Venus wounded by Diomedes, Venus presents a limp, boneless hand with no more grip than a surgical glove filled with water.

6. Nude Couple Embracing on a Bed

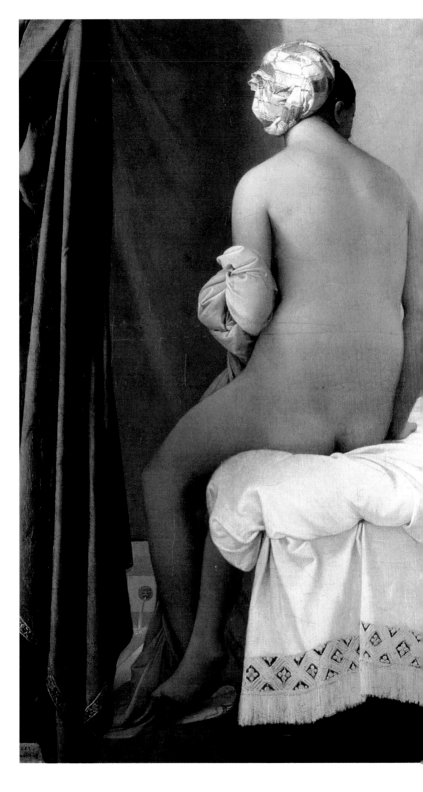

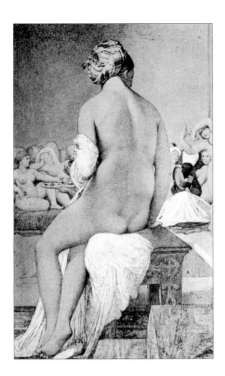

When it was first exhibited, the Grande Odalisque was criticized for having too many vertebrae in her back. It would quickly become apparent that this is the very least of her medical problems, were she to attempt to stand up and turn around to face the viewer. A displaced breast, lop-sided shoulders and a leg seemingly detached from the rest of her body would cause a lot more trouble than a few extra vertebrae. Her elongated limbs are as infinitely pliable as those of an inflatable doll.

7. Odalisque and Slave

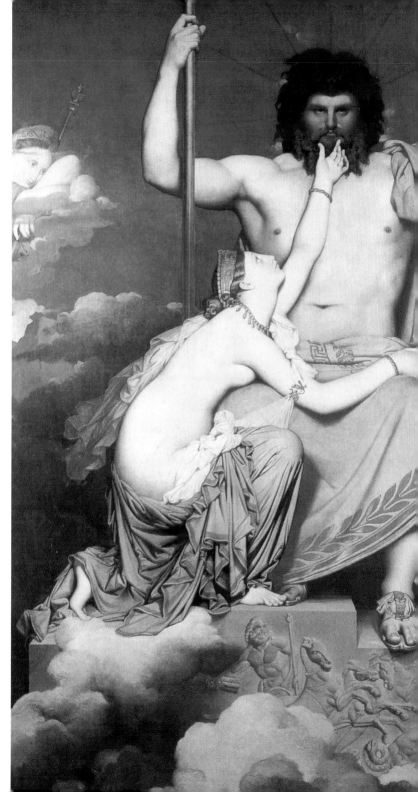

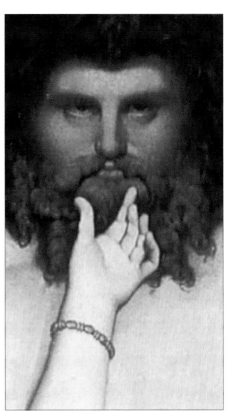

Among Ingres' most extraordinary anatomical inventions is the supplicant Thetis in *Jupiter and Thetis*, who thrusts her nerveless and rubbery fingers towards the face of Jupiter, whose male implacability is expressed in the monolithic frontality of his pose.

19

8. Jupiter and Thetis

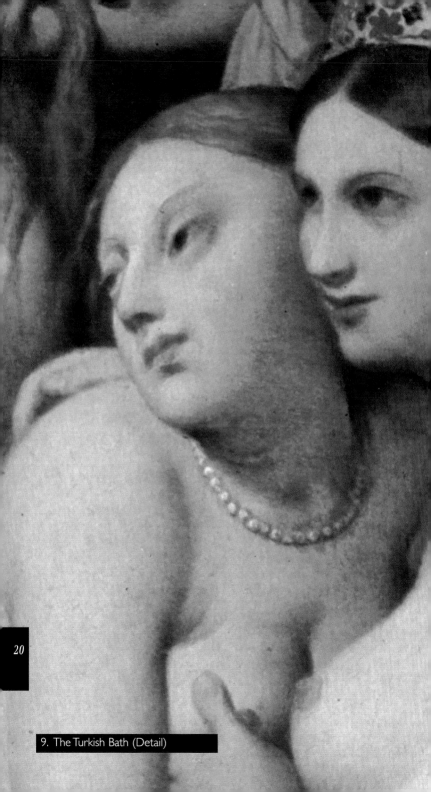

20

9. The Turkish Bath (Detail)

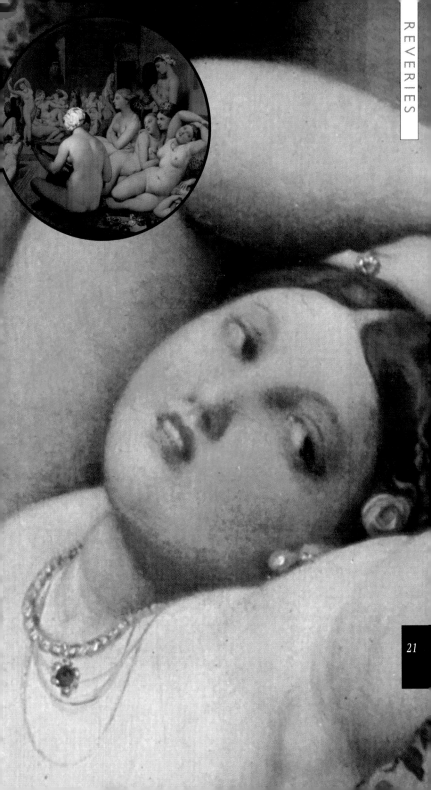

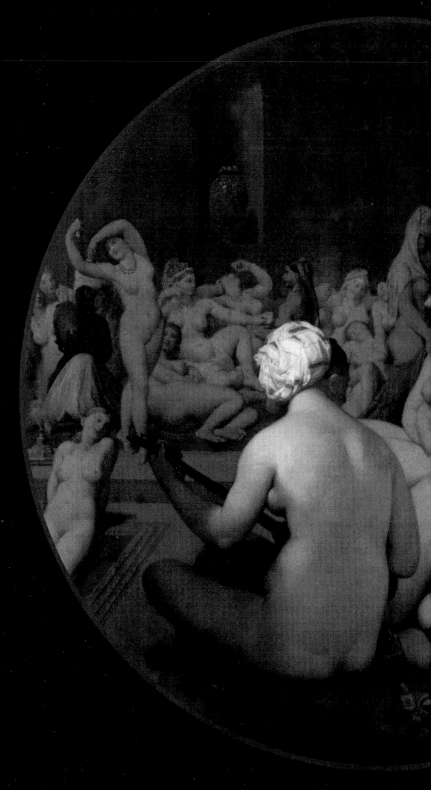

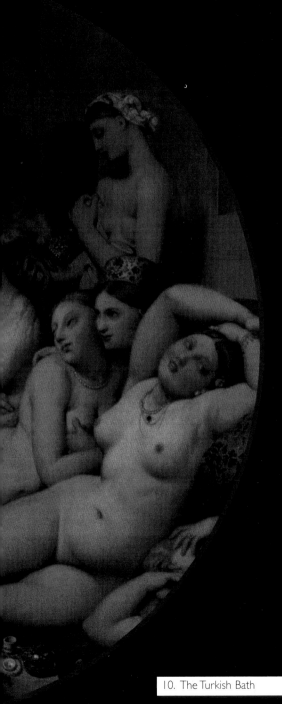

In the late Turkish Bath, the women's bodies are heaped up like living cushions. These women, incapable even of moving of their own volition, are the ultimate playthings for the male voluptuary.

23

10. The Turkish Bath

In the late *Bain Turc*, the women's bodies are heaped up like living cushions. These women, incapable even of moving of their own volition, are the ultimate playthings for the male voluptuary.

The sloping shoulders of the odalisque and of all of Ingres' women are another sign of their passivity and powerlessness. The way that shoulders are "carried", upholstered and presented is a telling indication of women's aspirations and position in society at any given moment. Though we tend to look back on the nineteenth century as a period in which women were grievously oppressed, the second half of the century was in fact a period of heroic progress for women.

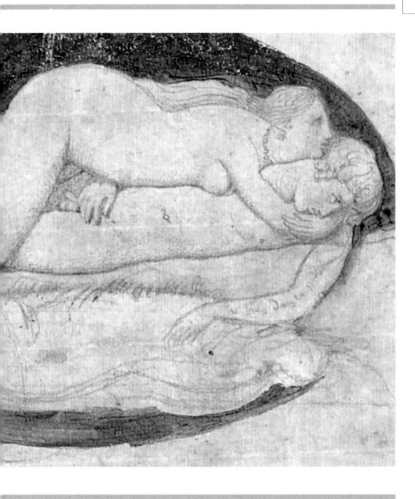

11. Nude Couple making Love

In Britain, the "Married Women's Property Act" of 1870, gave many women at least a modicum of control over their own lives. For a pioneering minority, opportunities were opening up in higher education and in some professions previously seen as exclusively male preserves. As these changes came into effect, so women's shoulders came increasingly into prominence between 1870 and 1900. Already in 1878, Edmond de Goncourt noted in his diary, "Degas, coming out of a house this evening, complained that one no longer saw any sloping shoulders in society. And he was right; that is a sign of physical breeding which is disappearing from the new generation of women." The process would be taken much further by the 1890s when, with the aid of elaborate padding, women's shoulders were developed to a grotesque state of exaggeration not seen again until the 1980s. With the aid of corsetry, women inflicted deformations upon themselves that were almost as radical as those of Ingres, and a visitor from another planet would have had little idea of the nude form of a woman from her outward appearance in society.

12. The Turkish Bath (Detail)

A comparison between the fashionable mid-nineteenth-century female portraits of Ingres and Winterhalter with portraits by Sargent and Boldini at the end of the century could lead one to suppose that the female of the human species had undergone an astonishing physical evolution in the space of two generations.

Throughout his career, Ingres was fascinated by women's clothes and fashion accessories. His female portraits, from Mme Riviere to Mme Moitessier in 1856, offer one of the most accurate and informative records of changes in women's fashions during the first half of the nineteenth century. The fleshy and phlegmatic Mme Moitessier is almost upstaged by her own dress, a spectacular flower-patterned crinoline, which spreads over the plushly upholstered chaise-longue on which she sits. Characteristically, Ingres changed her dress after having worked on the picture for several years in order to keep her up to date with the latest fashions.

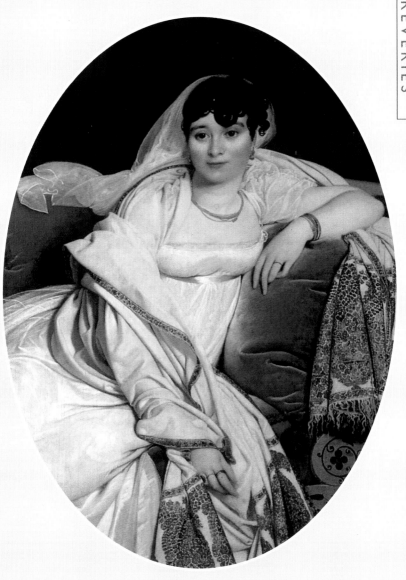

13. Madame Rivière

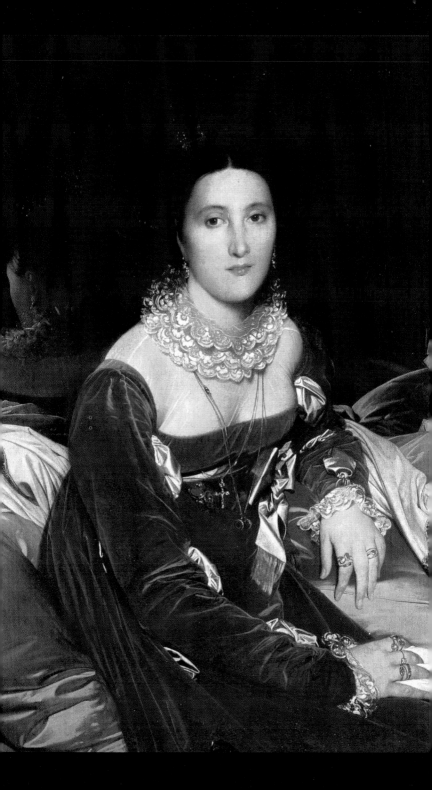

The atmosphere of almost suffocating sensuality in Ingres' female portraits is greatly enhanced by the artist's love of lavish accessories and furnishings and, above all, of richly coloured or patterned fabrics. Mme Riviere and Mme de Senonnes loll amongst luxuriant soft furnishings that fill up a large part of the picture surface.

14. Madame de Senonnes

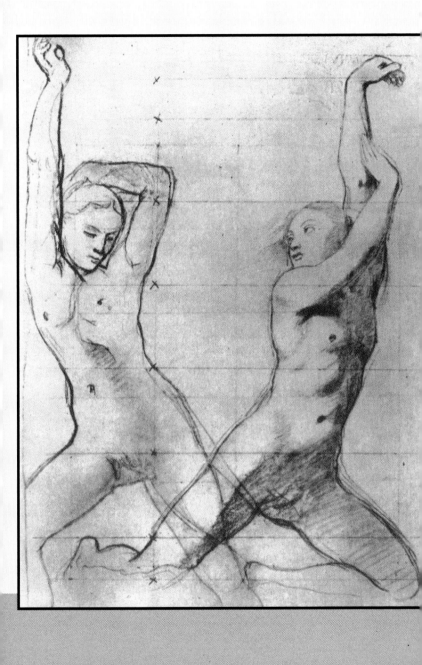

If Ingres' treatment of female anatomy is in general arbitrary and radical, his depiction of female pudenda in certain drawings is remarkably specific and accurate (figs 16 and 23). As a rule in western painting (and this also applies to Ingres' own exhibited works), neither pubic hair nor the opening of the vagina were acknowledged. The critic John Ruskin's study of Western art had left him so ignorant of this aspect of female anatomy that the shock of discovering on his wedding night that women have pubic hair left him unable to consummate his marriage.

15. Study of Nude Women for the
 Angels of the "Wish of Louis XIII"

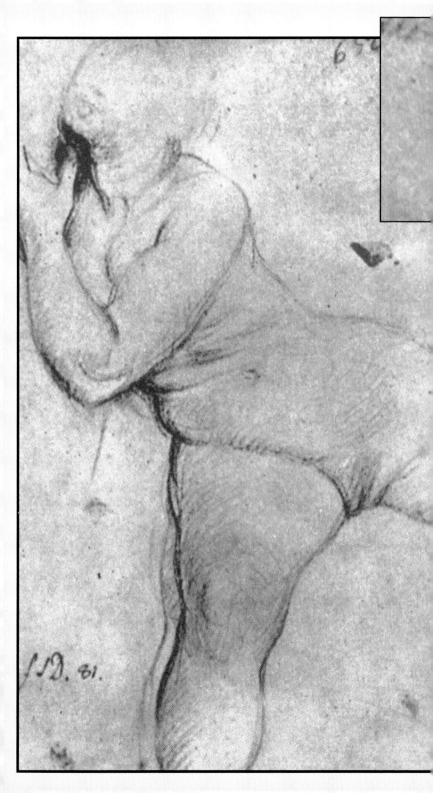

The explicitly sexual drawings in this book throw a rather unexpected light upon the artist who liked to present himself as the guardian of orthodoxy and who was so proud of all the official honours heaped upon him in later life. Such drawings were, of course, intensely private and intended largely for the artist's own delectation. They could never have been exhibited openly and could only have been sold, as it were, "under the counter" to specialized collectors of erotica, for which there was indeed a thriving market in the prudish and repressed nineteenth century.

16. Nude Woman

The survival rate for such works of art is not very high. Sooner or later most fall victim to the ire of an outraged collector's widow or to the piety of a devotee wishing to protect the reputation of a great artist. The most notorious example of the latter is the supposed destruction by Ruskin of a cache of erotic drawings by Turner.

This specialized genre, which might be popularly termed the "dirty drawing", brings Ingres close to artists with whom one would otherwise be unlikely to associate him, such as Fuseli and Gericault. When Gericault went to visit Ingres in his Rome studio, he enraged the touchy older master by enthusing excessively over his drawings and ignoring his paintings. It was at about this time that Gericault himself produced a number of erotic drawings of nymphs and satyrs that bear some similarity to Ingres' erotic drawings, though the element of violence is much more marked. Gericault clearly enjoyed scenes of rape, whereas in Ingres' drawings the sex is by and large consensual and in more than one case it is the woman who makes unwanted sexual advances to the man (figs 17–18).

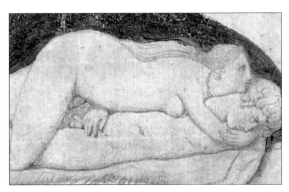

17. Nude Couple Embracing on a Bed

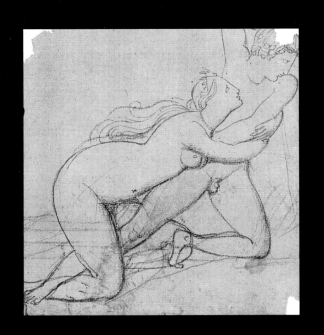

18. Nude Couple (Detail)

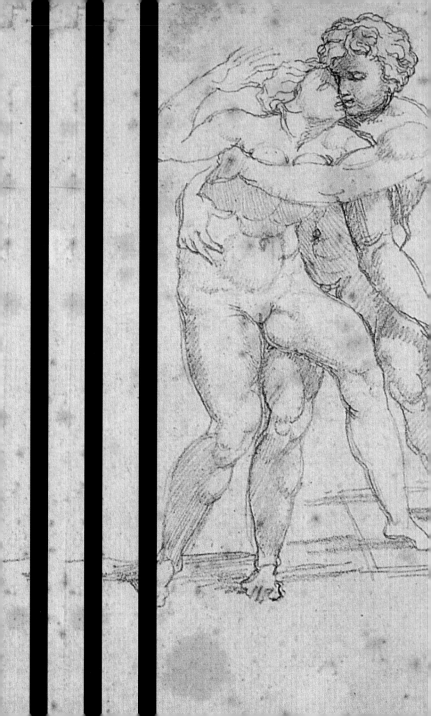

Any similarities between the erotic drawings of Ingres and Gericault are less likely to result from mutual influence than from the use of common sources. With its immensely rich two-thousand-year tradition of erotica, Italy had a great deal to offer young artists interested in such things. From the ancient world there were Greek vases, cameos, small bronzes and the recently excavated frescos of Pompeii and Herculaneum. But as the drawings illustrated in this volume attest, it was sixteenth century erotica that interested Ingres most of all.

The notorious *I Modi*, illustrations of love-making positions engraved by Marcantonio Raimondi after drawings by Raphael's pupil Giulio Romano and published in 1523, initiated a "golden age" of the erotic print. Several of Ingres' drawings illustrated here are directly copied from sixteenth-century erotic prints by Giulio Bonasone and others in the Mannerist style and very much influenced by Giulio Romano. Though the Michelangelesque muscularity of some of the female torsos might seem out of keeping with Ingres' tastes, the artist felt a strong affinity for the anatomical distortions and the balletic elegance of Mannerism, particularly its French flowering at the Ecole de Fontainebleau.

39

19. Man Embracing a Woman from Behind

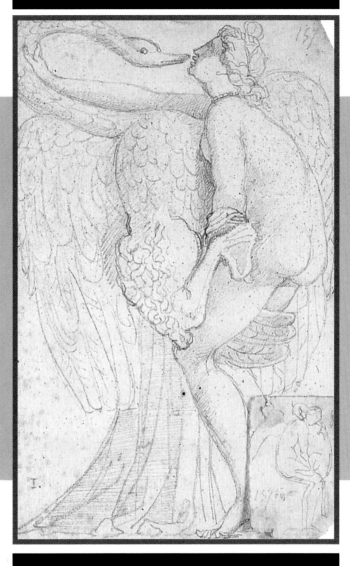

20. Leda and the Swan

At the age of twelve, when he was enrolled at the Academy in Toulouse, Ingres experienced perhaps the greatest aesthetic and emotional revelation of his life when he first saw a copy of Raphael's *Madonna della Sedia*. The perfect balance between realism and abstraction in this work, the way in which Raphael echoes the circular shape of the panel with an almost musical pattern of circular lines in this utterly natural image of a mother and child, became an aesthetic ideal that Ingres strived to emulate for the rest of his life. In his portrait of Mme Rivière, for example, Ingres combines a miniaturist's attention to detail with a design in which almost every contour and fold of drapery echo the curve of the oval format.

21. Nude Couple making Love

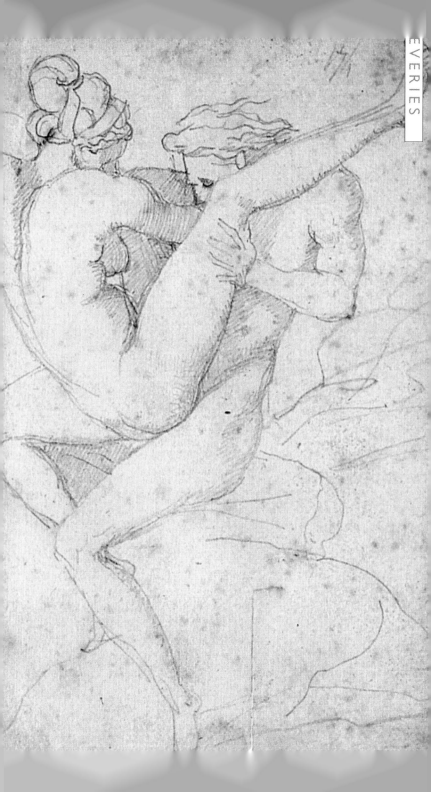

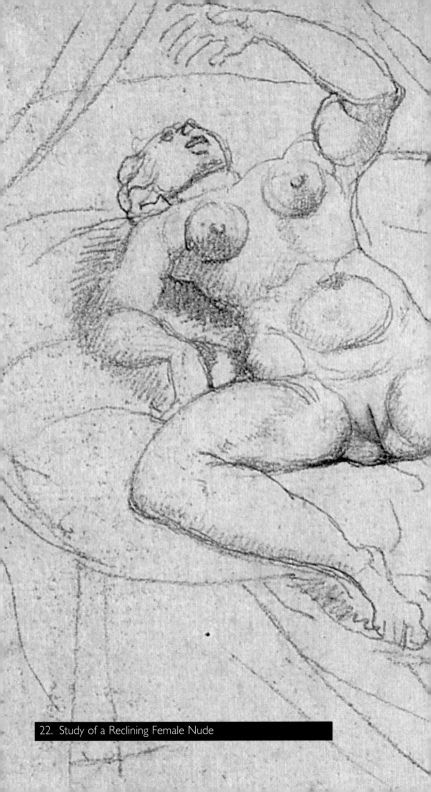

22. Study of a Reclining Female Nude

Quite apart from its aesthetic appeal, this most revered of Christian images also fed the erotic imagination of the youthful and indeed of the elderly Ingres in a way that seems almost blasphemous. (One can well understand why the work of Ingres was so fascinating to the Surrealists for whom blasphemy was elevated to a kind of credo.)

With fetishistic zeal, Ingres reproduced the image of Raphael's Madonna at every opportunity within his own paintings: as a print lying on a desk beside Monsieur Riviere; hanging on the wall above Henry IV playing piggyback with his children; and, most weirdly of all, woven into the carpet beneath the throne of the Emperor Napoleon. It is Raphael's Madonna della Sedia who sits demurely on the lap of Raphael in Ingres' painting of the Renaissance master with his mistress in his studio.

A comparison of the heads shows that it is Raphael's Madonna stripped naked whom we see in Ingres' highly erotic *Grande Odalisque*. The patterned headdress of the *Baigneuse de Valpincon* and the *Baigneuse à mi-corps* indicate that it is once again the Madonna seen nude and from behind. And she appears for the last time in the circular *Bain Turc*, signed with a shaking hand when Ingres was eighty-one years old.

45

Ingres' most notable depictions of the male nude date from early in his career when he was still attached to the studio of the great Neo-classical painter Jacques-Louis David. The sensuous or erotic treatment of the male nude was something that was sanctioned by the authority of classical art and was a principal reason for the attraction to Greek art of Johann Joachim Winckelmann, the great prophet of Neo-classicism. Winckelmann's homosexuality was well-known. His favourite protégé, the German painter Anton Raphael Mengs, slyly chose the homoerotic subject of Jupiter kissing Ganymede for a fake Greek fresco with which he intended to deceive Winckelmann. It cannot be assumed that David and Canova and their numerous followers and pupils had homosexual inclinations; nevertheless homo-eroticism is an important undercurrent in a great deal of Neo-classical painting and sculpture.

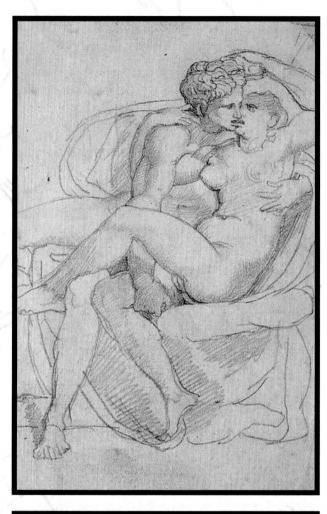

23. Seated Couple

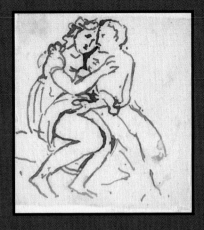

24. Studies of Couples

In 1801 Ingres won the "Prix de Torse" with a painted male nude that perfectly balances the real and the ideal and which is still in the collection of the Ecole des Beaux-Arts in Paris where Ingres was enrolled as a student. In the same year, Ingres won the coveted "Prix de Rome", and was the last painter of real genius to do so. Later in the nineteenth century the prize was consistently won by academic mediocrities. His competition entry, *The Ambassadors of Agamemnon in the tent of Achilles*, is his most ambitious and impressive treatment of the male nude. In her book, Ingres' *Eroticized Bodies,* the American feminist historian Carol Ockman offers a fascinating and plausible interpretation of this painting, laying considerable emphasis upon its homoerotic subtext. It should be remembered though that the subject was chosen by the Academy and that it was not a kind of subject matter he returned to later. His relative lack of interest in the male nude is one of the things that sets him apart from the mainstream of Neo-classical painting.

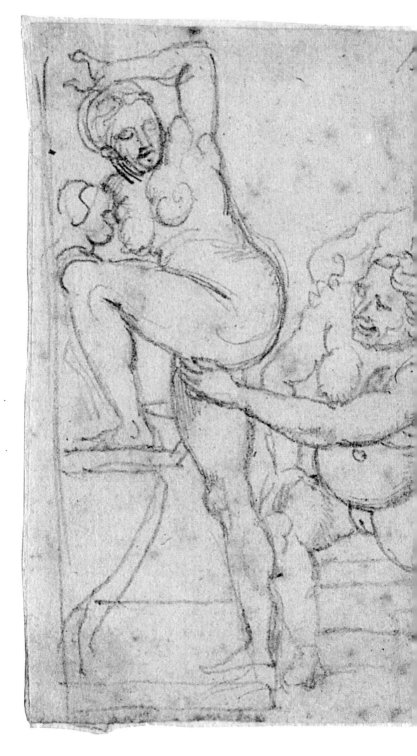

Ingres continued to make drawings from the male nude from time to time, which he needed for his classical and mythological subjects. He would also follow the academic practice of making nude life drawings of figures of both sexes, who would appear fully clothed in the final picture. There is something unintentionally hilarious about the nude study of the Princesse de Broglie standing in the same worldly and elegant pose she adopts in her drawing room in Ingres' painted portrait of her.

25. Three Women in a Bath

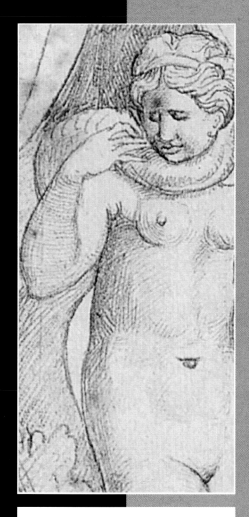

26. Nude Woman and a Dolphin

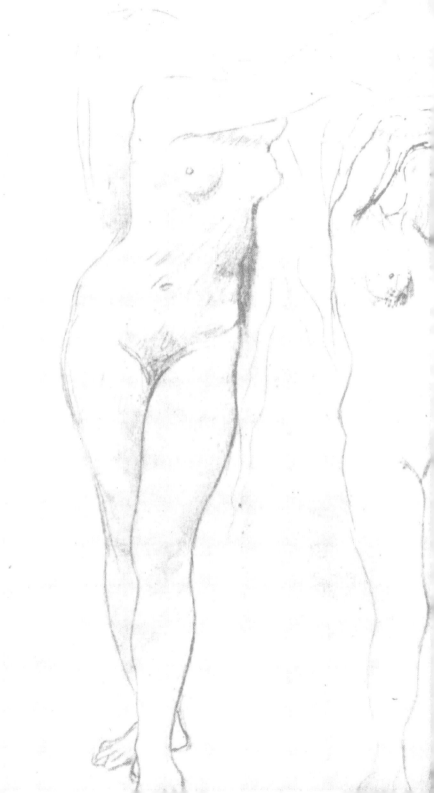

One of the loveliest and most seductive studies of this type is for the figure of Roger in Ingres' 1819 canvas *Roger freeing Angelica* (fig 27). In the final work Roger wears armour that some have interpreted as a metaphor for tumescence. It is certainly a work the strangeness of which invites Freudian interpretations. In the nude study for the figure of Roger, the model, who seems much younger than the Roger of the final picture, is given a tender and slightly feminized grace.

55

27. Study for the Figure of Angelica

Crucifixions, martyrdoms and corpses have always provided artists with a validation for the voluptuous treatment of the male nude. The outstretched male figures in fig.28, which are studies for the corpse of Acron in the painting *Romulus, Victor over Acron, carries the Spoils of War to the Temple of Jupiter*, could equally well express post-coital languor or the relaxation of death.

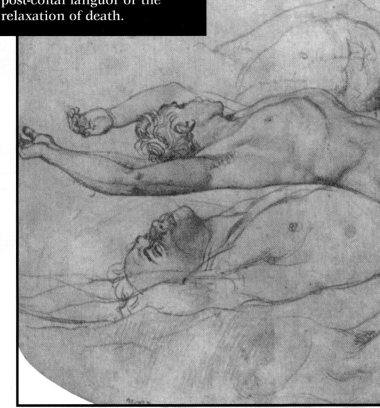

28. Study for the Corpse of Acron

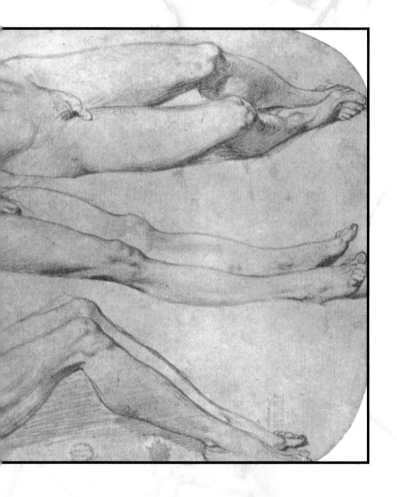

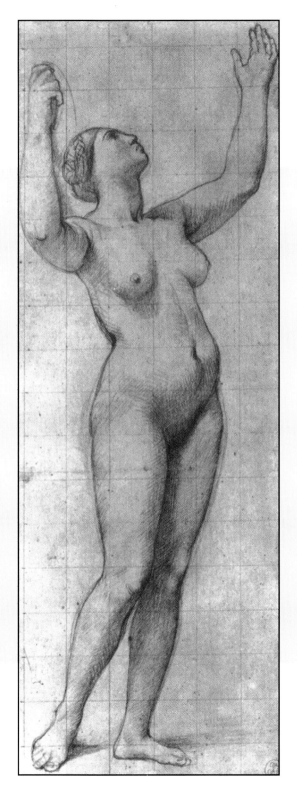

From the time of Gericault's visit to Ingres' Rome studio, there have always been those who prefer Ingres' preparatory life-drawings for the figures in his paintings to the finished works. Indeed many have a frankness that they lose in their painted versions. The drawing, squared up for enlargement, of a heavy breasted woman with her arms raised (fig.29) is a study for an allegorical figure of France in a ceiling painting of the *Apotheosis of Napoleon I*, which Ingres was commissioned to paint for the Paris Town Hall in 1853. The final painting, now known only from early photographs and a small-scale replica, was surely one of Ingres' least successful works and its destruction in 1871 can have done little to diminish the artist's reputation. A similarly fine study of a female torso (fig 31) was made for the figure representing the Muse of Lyric Poetry in Ingres' portrait of the composer Cherubini. The inferior execution of the figure in the final painting betrays the hand of an assistant rather than the master. The ravishing drawing of a nude couple (fig 32), with its characteristically sinuous line and minimal shading, was one of an enormous quantity made in preparation for two murals commissioned by the Duc de Luynes for the Chateau of Dampierre. Ingres evidently found making these drawings far more satisfying than painting the mural itself, which he eventually abandoned.

59

29. Study of a Female Nude for the "France in Mourning"

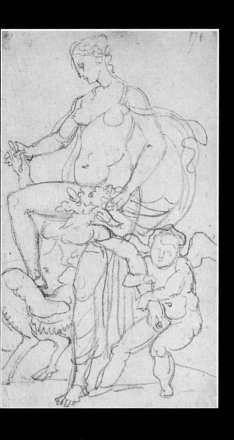

30. Woman and Satyr

31. Study of a Female Nude

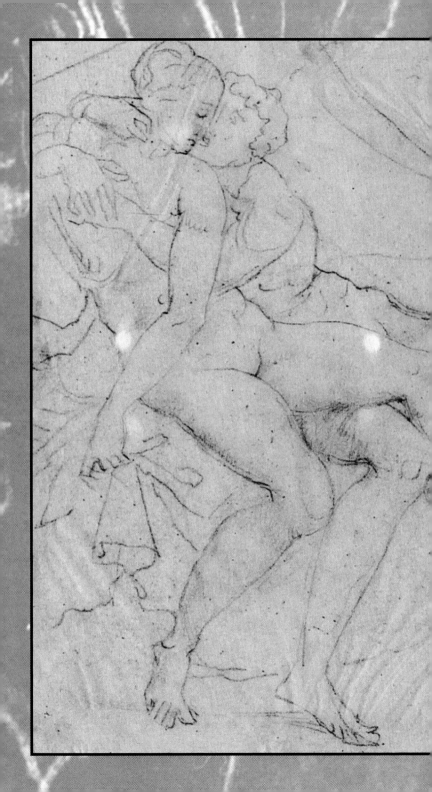

180.

Direct comparisons between the works of Ingres and those of his rival Delacroix are often futile because the two artists so rarely excelled in the same types of paintings. Delacroix had little talent for portraiture, an area in which Ingres reigned supreme for more than half a century, whereas Ingres entirely lacked the ability to organise and animate a large-scaled and multi-figured composition of the kind that brought out the best in Delacroix. The one genre in which they can be pitted against one another, with both performing at their best, is the orientalist fantasy.

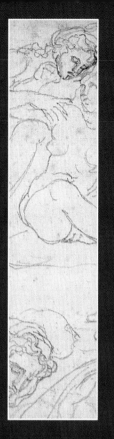

Orientalist subject matter in painting and literature had a long history in Europe, and especially in France. Whilst there were plenty of topographical views and scenes of every day street life produced, it was primarily sexual fantasies of harems and odalisques that fuelled the long-lasting interest in orientalism. This was initially stimulated by the publication of two influential books in the early eighteenth century: Montesquieu's *Lettres Persanes* of 1721, and Lady Mary Wortley Montagu's *Letters* of 1723. The descriptions of harems in the *Lettres Persanes* were based on second-hand accounts and fantasy, but the intrepid Lady Mary had been to Constantinople as wife of the British ambassador from 1716 to 1718. Her vividly detailed accounts of life inside Turkish harems and women's baths were based on first-hand observation and whetted the prurient curiosity and salacious appetites of European males for the next hundred years. A French translation of 1805 was an important source for Ingres' paintings.

32. Nude Couple

MI 8673673

The Swiss artist Jean-Etienne Liotard
lived in Constantinople from 1738 to
1742 and produced the most wonder-
fully accurate pastels of Turkish
women in their exotic costumes. For
years thereafter he travelled the capi-
tals of Europe as the "Turkish painter"
with a trunk full of Turkish costumes
with which he clothed himself and his
sitters, until in advanced middle age
he married a young Dutch girl who
insisted on the removal of his "Turkish"
beard, thereby depriving him of his
novelty value and much of his patron-
age. The detachment with which Lio-
tard recorded the customs of Constan-
tinople and the delight with which his
European patrons donned his exotic
costumes were both symptomatic of
the greater openness to and tolerance
of alien cultures brought about by the
Enlightenment. In 1782 Mozart and his
librettist went so far as to depict a Mus-
lim pasha as a man of honour whose
generosity shames his Christian cap-
tives in the opera *The Abduction from
the Seraglio.*

33. Seated Couple

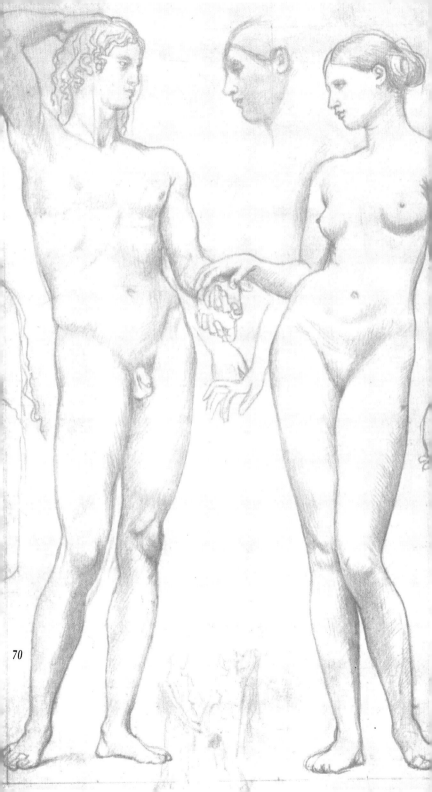

70

A series of political events served to prolong French interest in the Near East and North Africa through the nineteenth century and beyond. In 1798, Napoleon invaded Egypt, triggering a brief craze in the decorative arts for all things ancient Egyptian. In the 1820s, the plight of the Greeks in their struggle for independence from the Turks won the sympathies of liberals throughout Europe, but it is clear from Delacroix's *Massacre at Scio* that Romantics retained a covert affinity with the "barbarous" exoticism of the Turks. In 1827 the Dey of Algiers made the fatal error of striking the French Consul with a fly whisk, which, along with other diplomatic squabbles, offered the French the excuse to invade Algiers in 1830, so initiating the French colonization of North Africa which lasted until the 1950s. Delacroix travelled through Morocco and Algeria in 1832, blazing a trail followed by Gérôme, Renoir, Gide, Saint-Saens and many other French cultural luminaries over the next century. Ingres himself never went. It might be argued that his orientalist fantasies based on literature and popular prints were so potent that the reality of North Africa under French colonial rule might have tarnished them.

34. Study of a Nude Man and Woman for "The Golden Age"

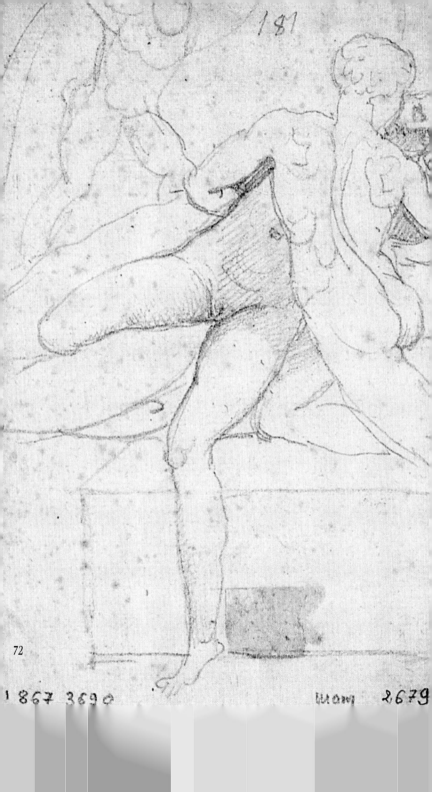

181

72

In Ingres' orientalist canvases, his erotic sensibilities are distilled to produce his most memorable images. His portraits aside, these paintings are undoubtedly his greatest works. Considering how large they loom in an extensive oeuvre produced over a period of more than sixty years, it is surprising that there are only four major orientalist paintings and a number of variants based upon them.

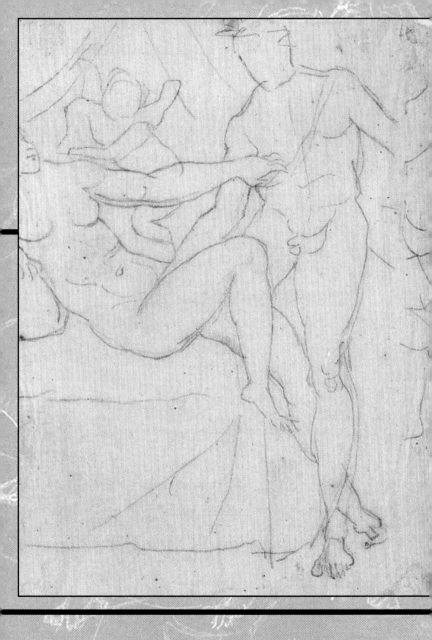

36. Cupid Showing Apollo Daphne Seated on a Bed

The first of Ingres' bath-house nudes was the *Baigneuse de Valpincon* (so-called after its original owner, who bought it from the artist for 400 francs), which Ingres sent back to the Paris Academie in 1808 as evidence of his progress as a state-funded student at the Villa Medici in Rome. In no other work does Ingres surpass the precarious balance of sensuality and icy formal perfection that he achieved here. The effect of the picture is restrained to the point of severity and it is entirely without the claustrophobic luxuriousness of Ingres' later orientalist canvases. The orientalist elements are discreet, confined to the patterned turban (which also refers to the headdress of the *Madonna della Sedia*) and the jet of water falling into the sunken bath. It is only in later versions of the subject, such as Fig 48, that the stillness of the solitary bather is invaded by a crowd of plump and noisily self-indulgent concubines eating and dancing in the background.

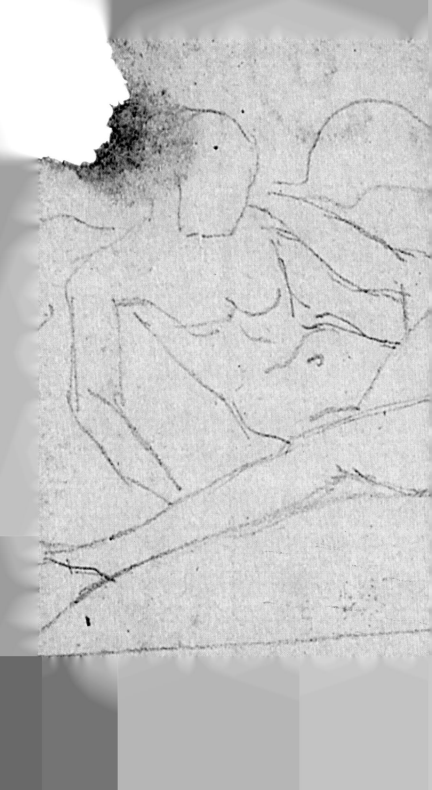

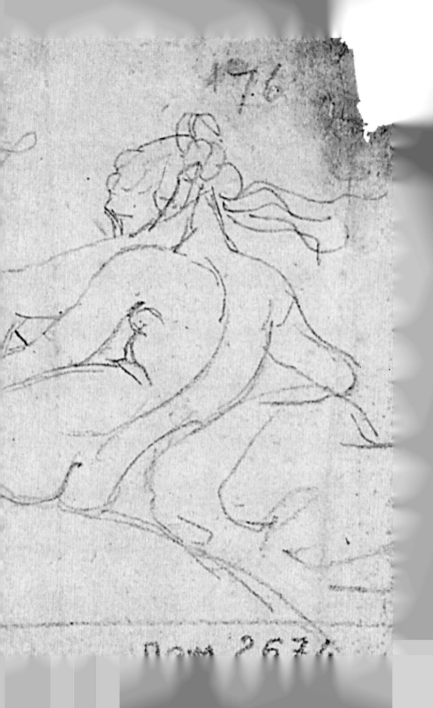

In the *Grande Odalisque* of 1814, the balance is tilted towards sensuality and exoticism. Preliminary studies (Fig 43) show Ingres searching his way towards the serpentine contours that, for all the anatomical distortions, are so satisfying and seemingly immutable in the final version. The *Grande Odalisque* was commissioned by Caroline Murat, Napoléon's younger sister and the Queen of Naples, as a pendant for the so-called *Sleeper of Naples,* which her husband Joachim Murat had bought from Ingres in 1809. No doubt inspired by gossip about Canova's notorious nude sculpture of Caroline's sister *Pauline Borghese as Venus* (she scandalized a lady who inquired whether she had really posed for it with the casual observation that Canova's studio had been well-heated), a rumour circulated that Ingres had intended to depict the Queen of Naples herself as the

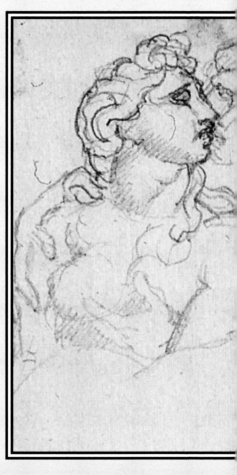

odalisque. Ingres indignantly refuted the suggestion, writing to the French ambassador in Naples, "This is absolutely false; My model is in Rome, it's a ten-year-old girl who modelled..."

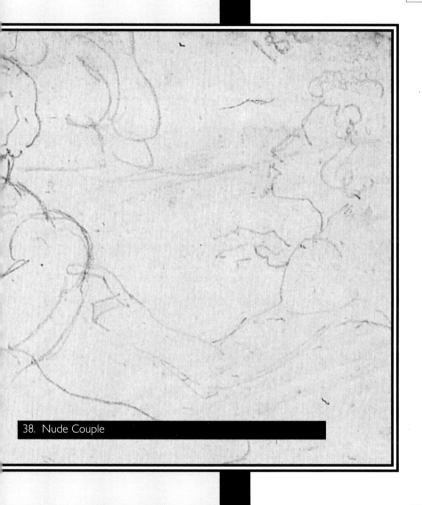

38. Nude Couple

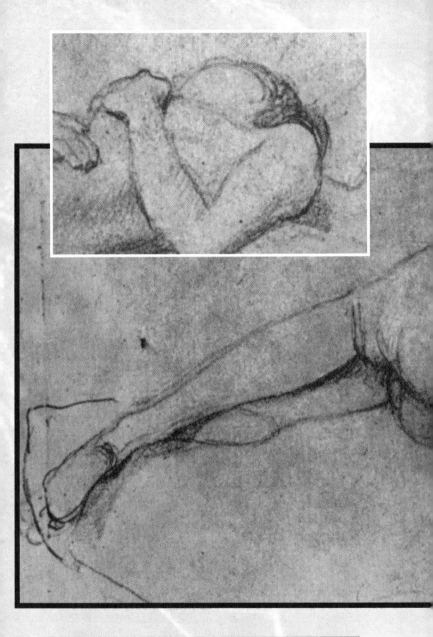

39. Study of a Nude Woman in Bed

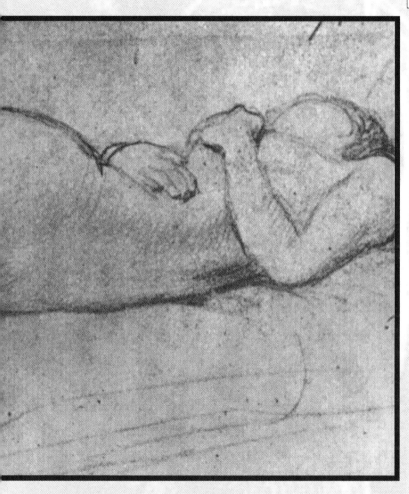

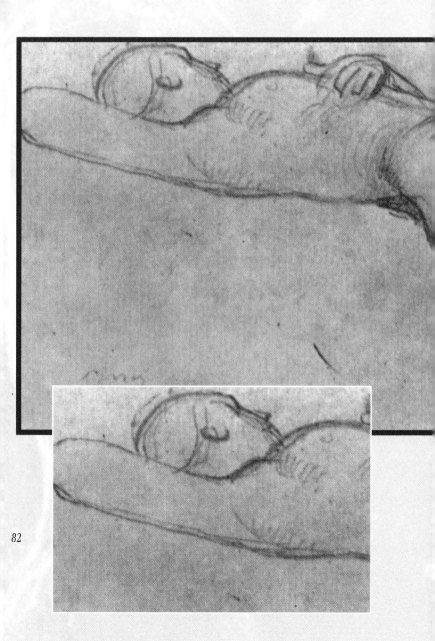

40. Study of a Reclining Male Nude

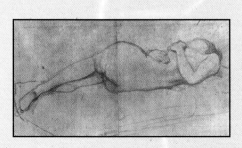

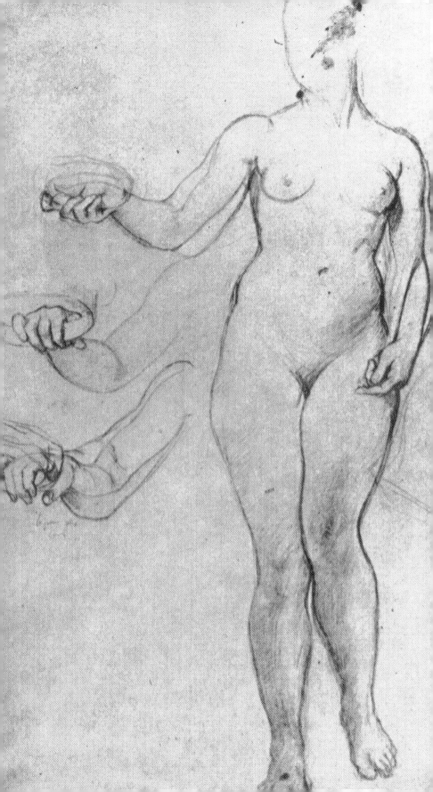

So far removed from natural appearances is this disturbing creature that the question of whether the model was a middle-aged queen or a ten-year-old Roman girl becomes quite irrelevant. For once Ingres has created a woman who is genuinely mysterious and not merely vacuous. The overall effect of the picture, with its confined space and sumptuous fabrics and its hints of narcotic as well as sexual pleasures, is stiflingly voluptuous. The piquant combination of peacock blue and mustard yellow belies Ingres' reputation for being indifferent to colour. (A reputation for which his own pompous pronouncements were largely to blame.)

41. Study of a Female Nude

42. Hermaphrodite Attempting
 to Escape from Salmacis

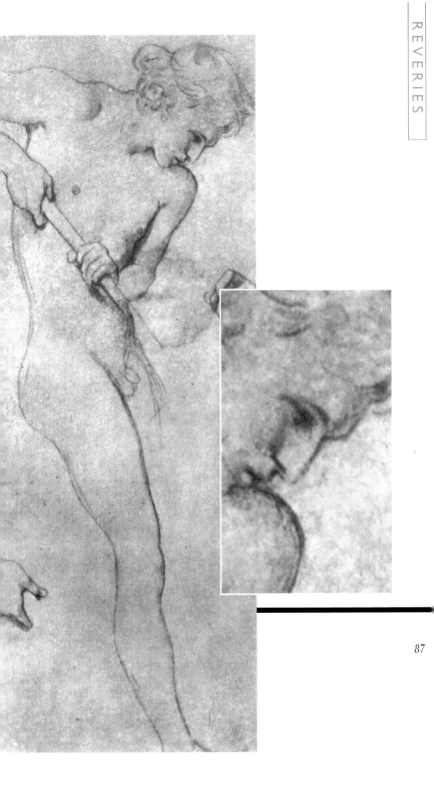

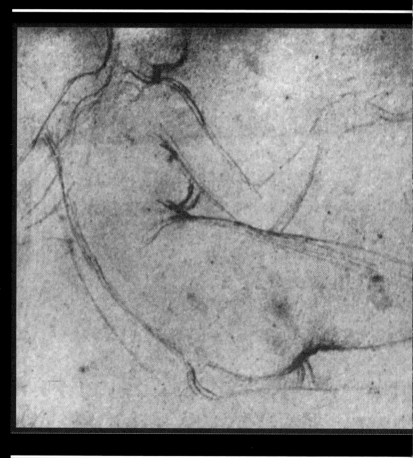

43. Study of a Reclining Female Nude for the Odalisque

44. Study of a Reclining Female Nude for the Odalisque

Ingres returned to the theme of the odalisque in 1839, five years after Delacroix had exhibited his definitive version of the subject in *The Women of Algiers* at the Salon. Ingres painted two versions of the *Odalisque with Slave*, the first for his friend Monsieur Marcotte, whose portrait he had earlier painted in Rome, and a variant for the King of Wurttemberg, which is dated 1842. The extraordinarily abandoned pose of the odalisque in both painted versions and in a highly finished pen and ink version (fig 43–44), derives from *The Sleeper of Naples*, which was apparently destroyed at the fall of the Napoleonic regime in Naples in 1815.

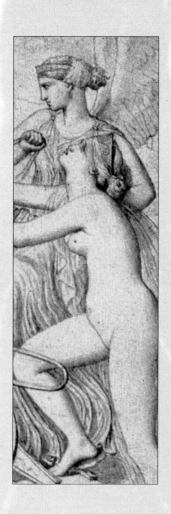

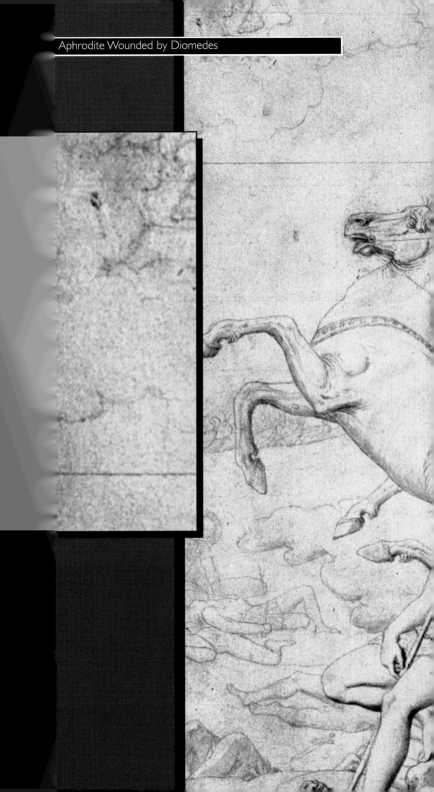

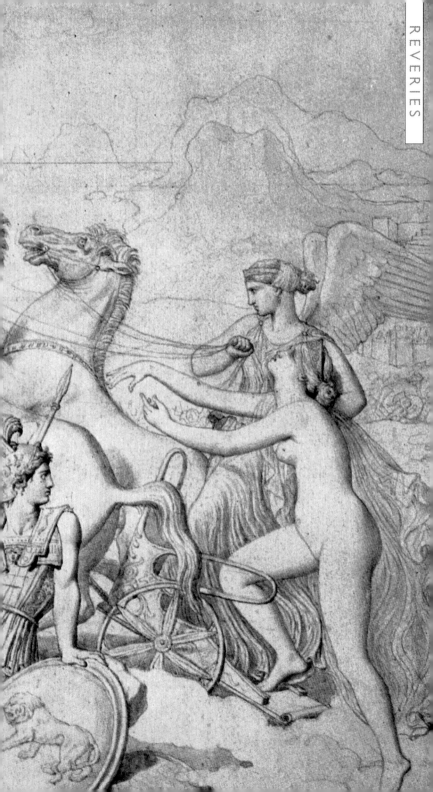

Ingres had attempted to buy the picture back and clearly valued it highly. After that of the *Baigneuse de Valpincon*, the pose of the Sleeper is probably the one that Ingres reproduced most often throughout his career. The preparatory drawings illustrated in figs 41 and 42 show Ingres once again tinkering with and attempting to perfect the pose for Monsieur Marcotte's picture.

46. Study of a Reclining Female Nude

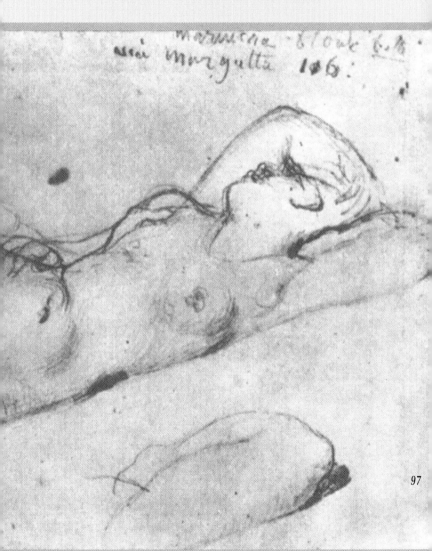

In the two painted versions of *Odalisque with Slave* the Islamic interior had become still more opulent with an almost dizzying effect of pattern placed against pattern, all rendered with the minute touch of a miniaturist.

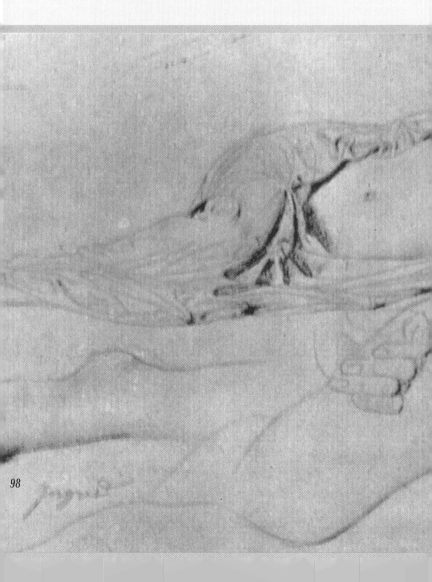

47. Two Studies of Reclining Female Nudes

48. Odalisque of Bather
seen from the Back

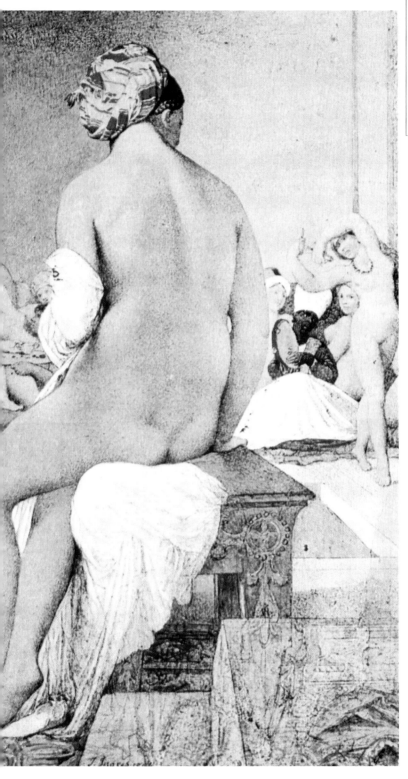

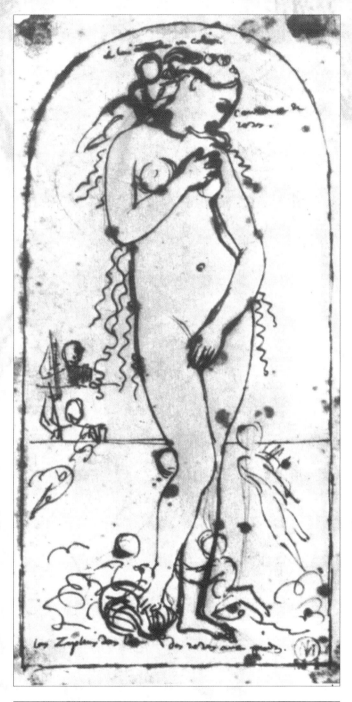

49. Neptune Enjoying Thetis

The *Bain Turc*, completed in 1863, the year of Delacroix's death, is Ingres' final masterpiece. It is a grand summing up of a life's work and also of a lifetime's sexual obsessions, in which we meet several old friends for the last time. The *Baigneuse de Valpincon*, seated on the floor, plays the mandolin, while Angelica, freed from the phallic rock to which she was once chained, dances amongst the riotously self-indulgent company at the back of the picture. (The study for Angelica - fig.27 - could equally well have served for the dancer.) On the right, we see an extraordinary pile of soft, pneumatic limbs and torsos. It is not entirely clear which limbs are attached to which torsos or whose fingers are squeezing whose nipples.

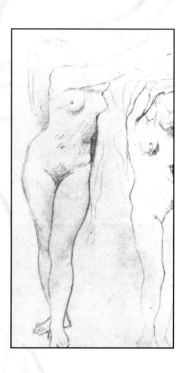

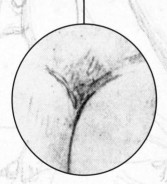

There is a heady under-tone of lesbianism, which was exciting to a number of nineteenth-century French writers and painters. It is not entirely surprising that after moral squeamish-ness had prompted the picture's rejection by Prince Anatole Demidov and by Prince Napoleon, it was finally purchased by Khalil-Bey, the Turkish ambassador to France, who later com-missioned Courbet's *Sapphic Sleepers*.

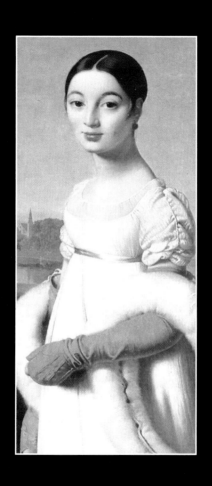

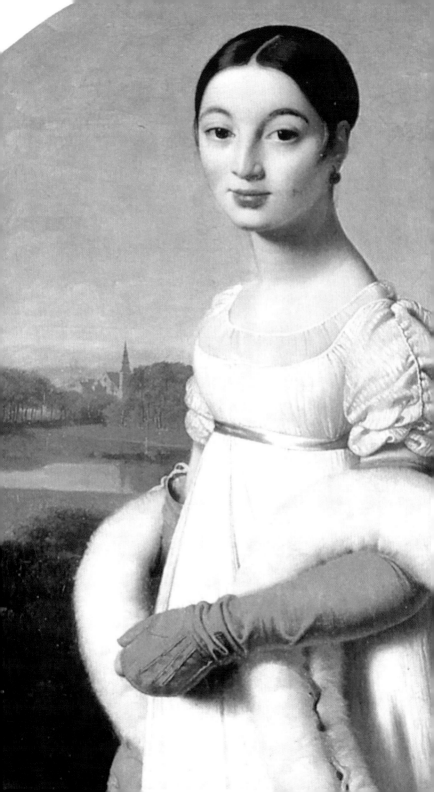

50. Mademoiselle Rivière

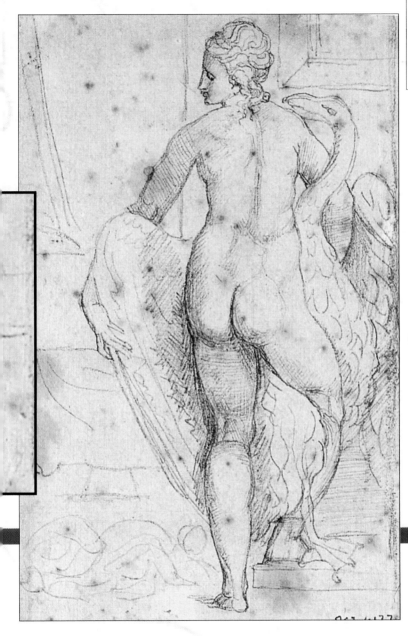

51. Leda and the Swan

By the 1860s Ingres was generally regarded as a die-hard reactionary who embodied everything against which the younger generation was in revolt. Orientalism too was becoming tired and cliched in the hands of Salon painters such as Gerome. Amongst the Impressionist generation only Renoir flirted briefly with the odalisque. But odalisques and harems were given a new lease of life by the sensational success of the ballet *Scheherazade*, which was presented by Diaghilev's Ballets Russes in 1910. The designs of Leon Bakst, whose suave and voluptuous line surely owes a heavy debt to Ingres, had a powerful impact on fashion and interior design. Smart Parisian hostesses dressed themselves as turbaned concubines and scattered multicoloured cushions around their living rooms as though for an orgy.

52. Madame Ingres

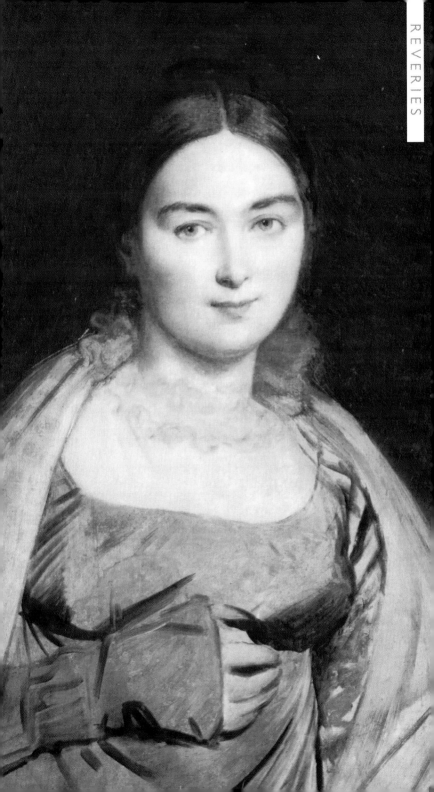

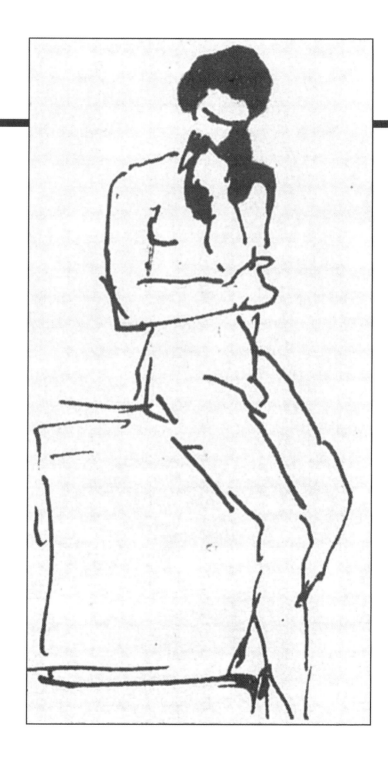

By the inter-war period, when Matisse was attempting to meld the colour of Delacroix with the line of Ingres in a series of odalisques, intended as an homage to both masters, and Picasso acknowledged a debt to Ingres in his erotically charged nude portraits of his mistress, Marie-Thérèse Walter, Ingres had been fully rehabilitated. He was claimed as a precursor of Cubism because of his distortions of form and of Surrealism because of his rendering of the unnatural in a quasi-photographic technique. Having since then survived a wave of feminist disapproval, Ingres continues to provoke and fascinate, not least because of the peculiar intensity of his erotic fantasy and sensibility.

53. Nude Man

54. Study of a Reclining Woman

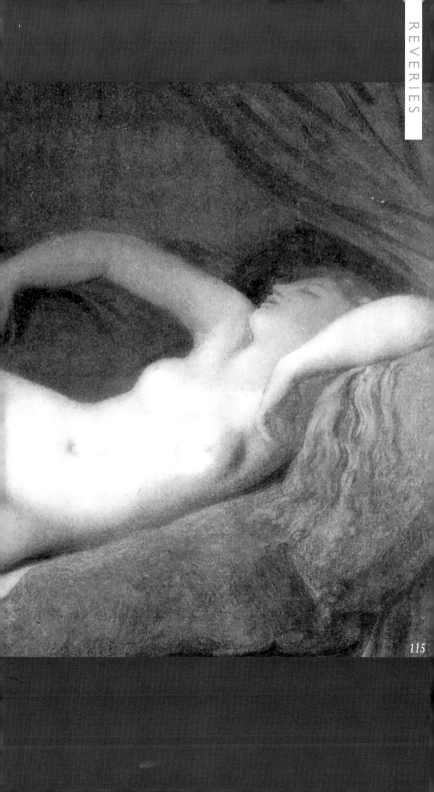

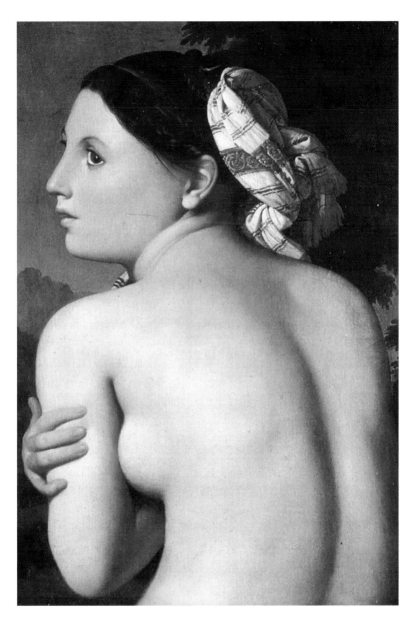

55. Half-length Bather

BIBLIOGRAPHY

CAROL ACKERMAN,
Ingres' Eroticized Bodies
Yale University Press
1995

P. COURTHION
Ingres raconté par lui-même et par ses amis
Geneva
1947-8

ROBERT ROSENBLUM
Ingres
Thames and Hudson
1990

N. SCHLENOFF
Ingres, ses sources littéraires
Paris
1956

G. WILDENSTERN
Ingres
London
1954

ILLUSTRATIONS: